Samurai
ARMS AND ARMOR

MING-JU SUN

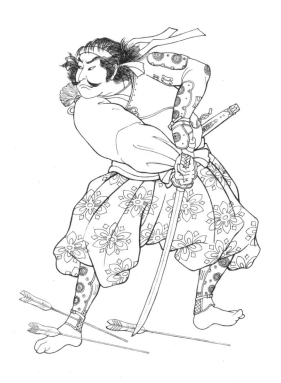

DOVER PUBLICATIONS, INC., MINEOLA, NEW YORK

NOTE

The proficiency of the samurai in battle is a fascinating display of finely honed sword skills and bravery. The word *samurai* derives from the Japanese word *saburai*, which means "one who serves." The arms and armor of the samurai—Japan's elite military class—possess a beauty in their precision, strength, and durability that is greatly admired by cultures throughout the world. The classic ingredients of traditional samurai legends retell captivating tales of valor and heroic deeds that honor the strict precepts of *bushido*, or the way of the warrior.

With his deadly sword and indomitable spirit, the samurai was expected to engage in mortal combat on behalf of his master at any time. No greater honor existed for a warrior than to die with glory in the service of his warlord. A samurai's accoutrements, including his weaponry, armor, and even the use of fur on his clothing, emphasized his brutality and lent him a more menacing appearance. A high-ranking warrior's military arsenal also consisted of a variety of spears, firearms, and swords adorned with material or bear fur to simulate a tiger's tail. In addition, the samurai wore face masks sculpted into ferocious expressions to intimidate the enemy. In a fight to the death, any advantage gained over an opponent was crucial, since only the finest warriors survived the duel.

Exquisitely rendered by artist Ming-Ju Sun, the thirty plates in this book depict historical samurai figures with authentic swords, armor, and weapons. A majority of the illustrations presented here are based on the majestic stories of samurai loyalty and wartime treachery, as portrayed by Japanese artist Utagawa Kuniyoshi (1797–1861) in his famous warrior print set, *Taiheiki eiyū den (Heroic Biographies from the "Tale of Grand Pacification")*.

Copyright

Copyright © 2008 by Ming-Ju Sun
All rights reserved.

Bibliographical Note

Samurai Arms and Armor is a new work, first published by Dover Publications, Inc., in 2008.

DOVER *Pictorial Archive* SERIES

This book belongs to the Dover Pictorial Archive Series. You may use the designs and illustrations for graphics and crafts applications, free and without special permission, provided that you include no more than four in the same publication or project. (For permission for additional use, please write to Permissions Department, Dover Publications, Inc., 31 East 2nd Street, Mineola, N.Y. 11501.)

However, republication or reproduction of any illustration by any other graphic service, whether it be in a book or in any other design resource, is strictly prohibited.

International Standard Book Number
ISBN-13: 978-0-486-46557-9
ISBN-10: 0-486-46557-8

Manufactured in the United States by Courier Corporation
46557802
www.doverpublications.com

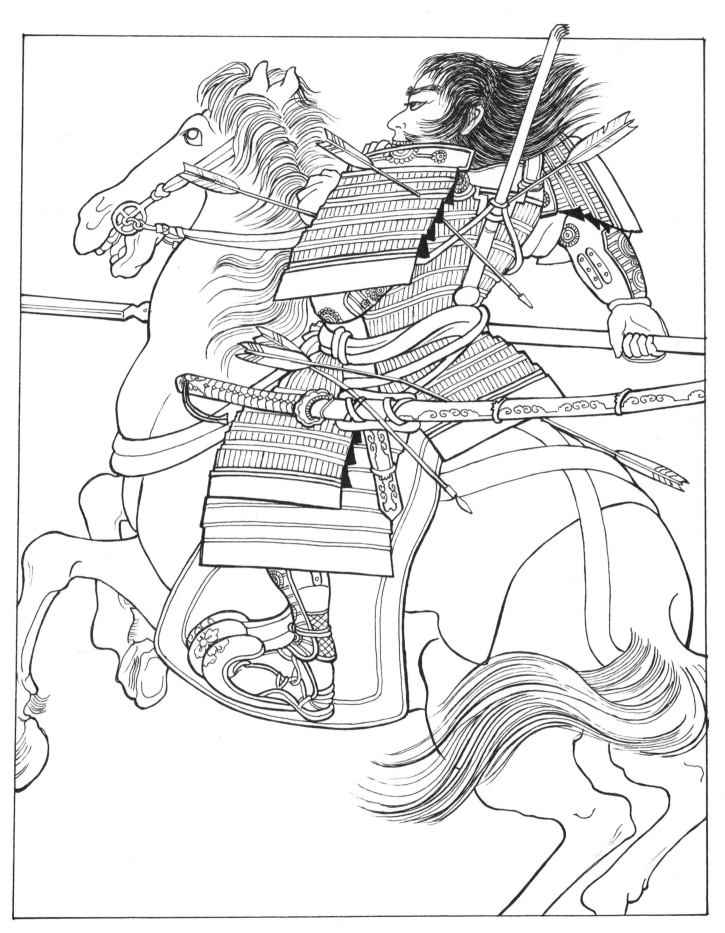

1. A vassal of the Ōta house, Haigō Gozaemon Hisamitsu is portrayed here on a rearing horse during the battle of Shizugatake. With arrows already puncturing his armor, this valiant warrior is fighting his last skirmish. He perished in action after he was struck by a spear that pierced through the breastplate of his armor.

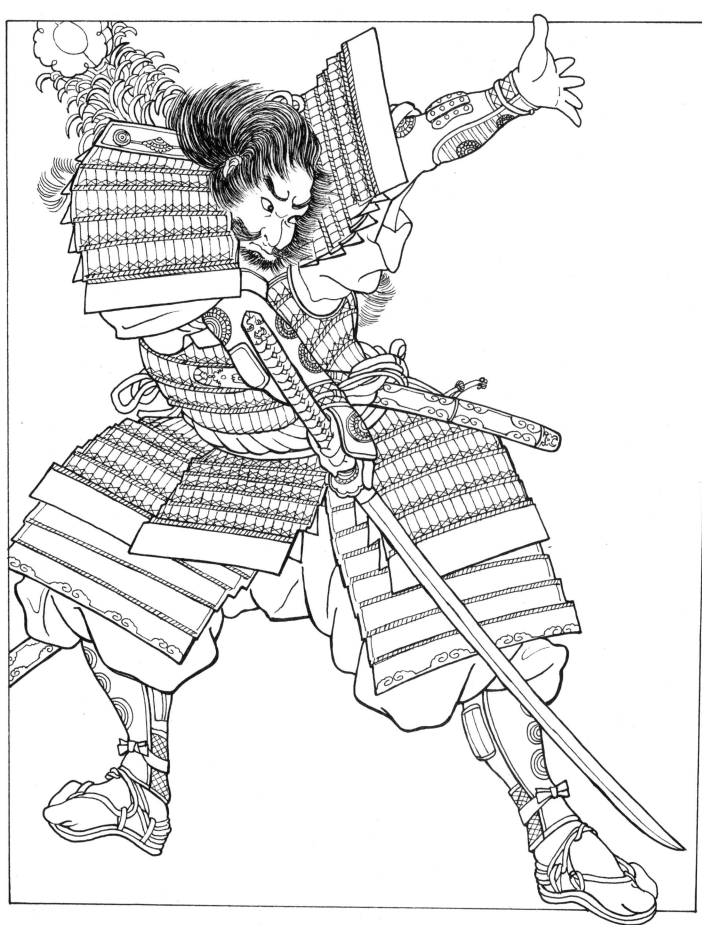

2. A warrior of unparalleled strength, Yamaji Shōgen Masakuni is depicted in a fierce moment of battle. His tense, combative stance indicates the lengthy battle he waged with his adversary before a misstep on a rocky hillside sent them both rolling down a ravine.

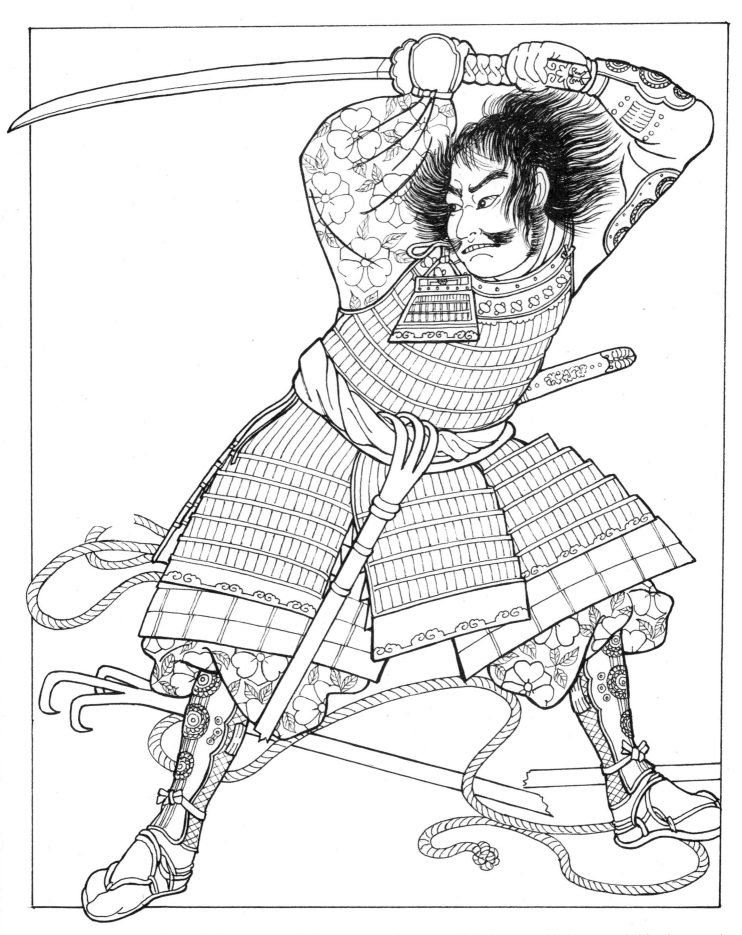

3. A daring veteran who carried an enormously heavy iron club, Sakuma Genba Morimasa decided to take a secret path to outwit the enemy, but his provisions had run out. When he drew closer to a village, he was suddenly surrounded by the enemy's brave vassals. Morimasa tried to cut his way through, but he soon grew weary from his exertions, and was finally captured alive.

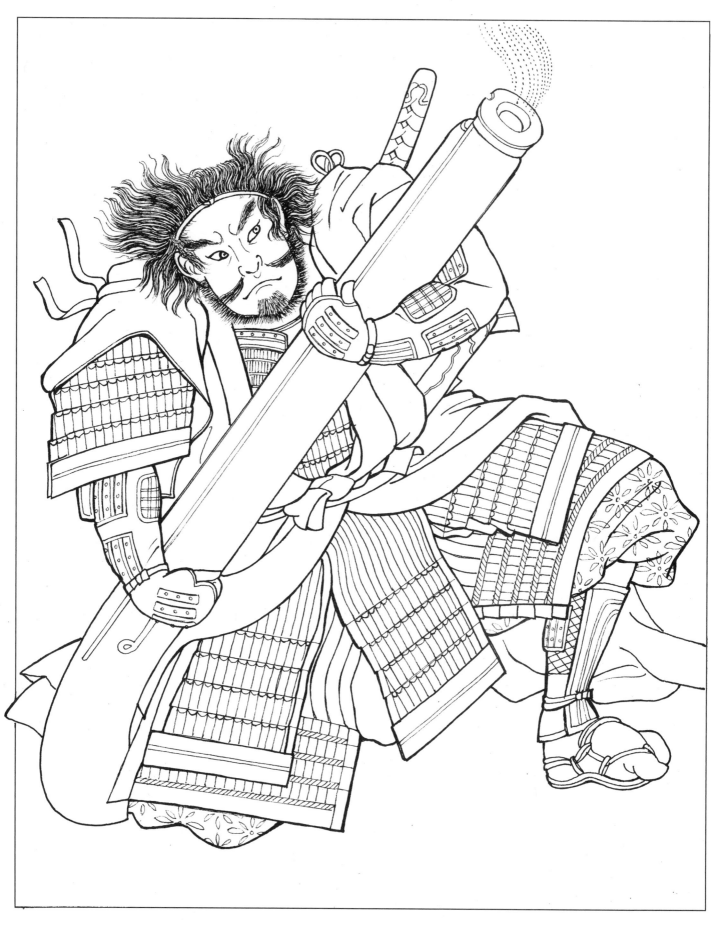

4. The samurai pictured above is firing a large-caliber musket known as a wall-gun. Some
varieties of this weapon fired wooden, rocket-shaped projectiles.

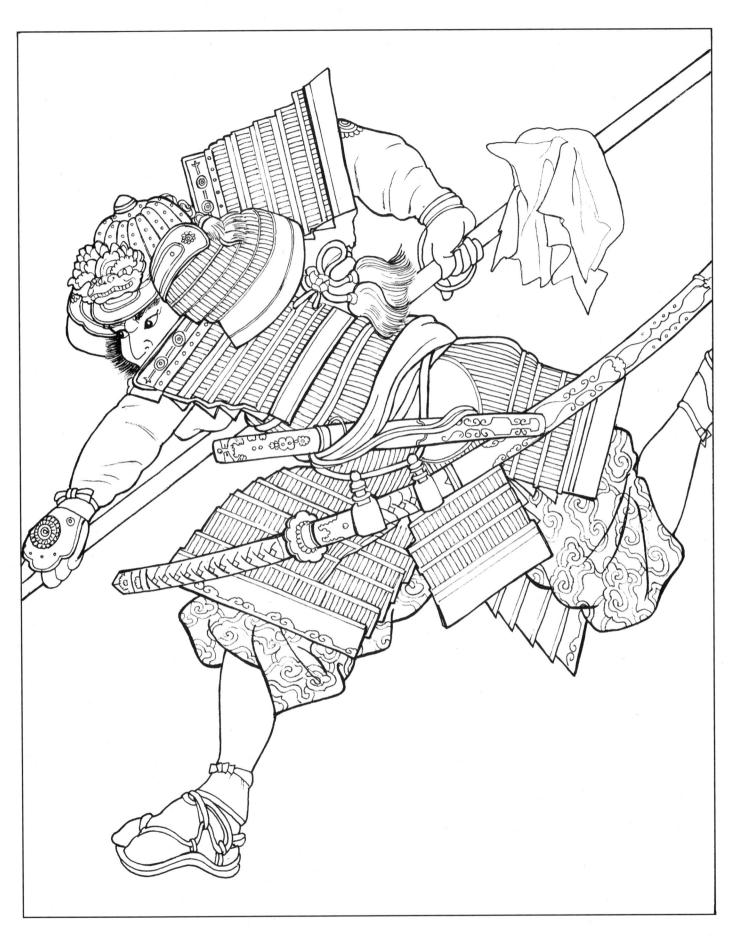

5. This figure in action wears full armor, including two swords and a dome-plated helmet with high sides. Both of his swords are finely decorated with elaborate markings.

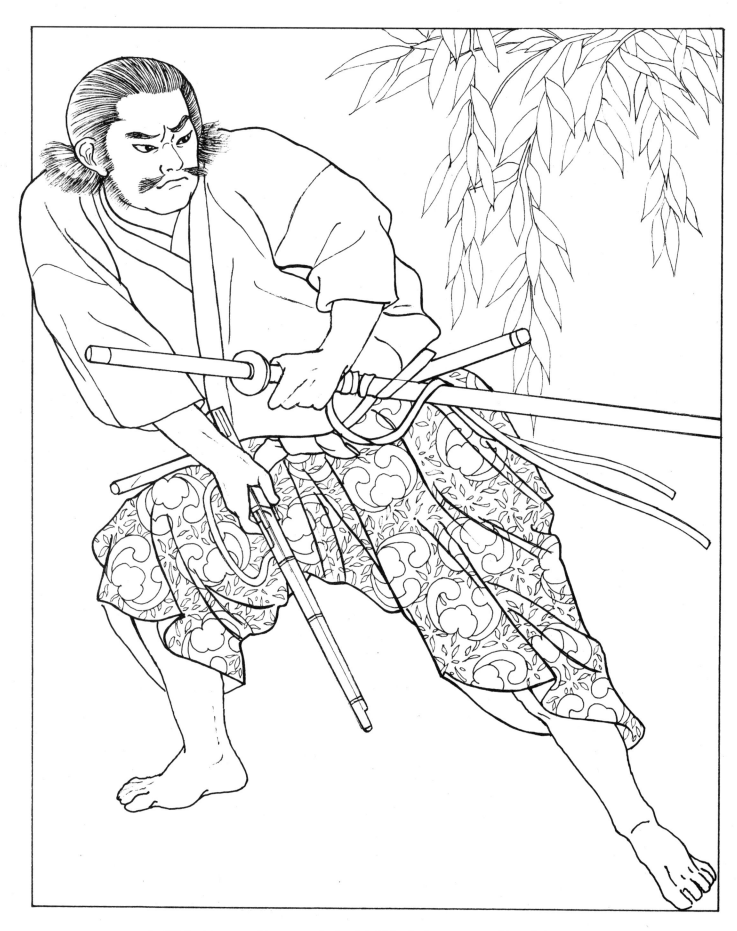

6. While this samurai is not on the battlefield, he is shown engaged in a fight wearing double swords and carrying a matchlock pistol.

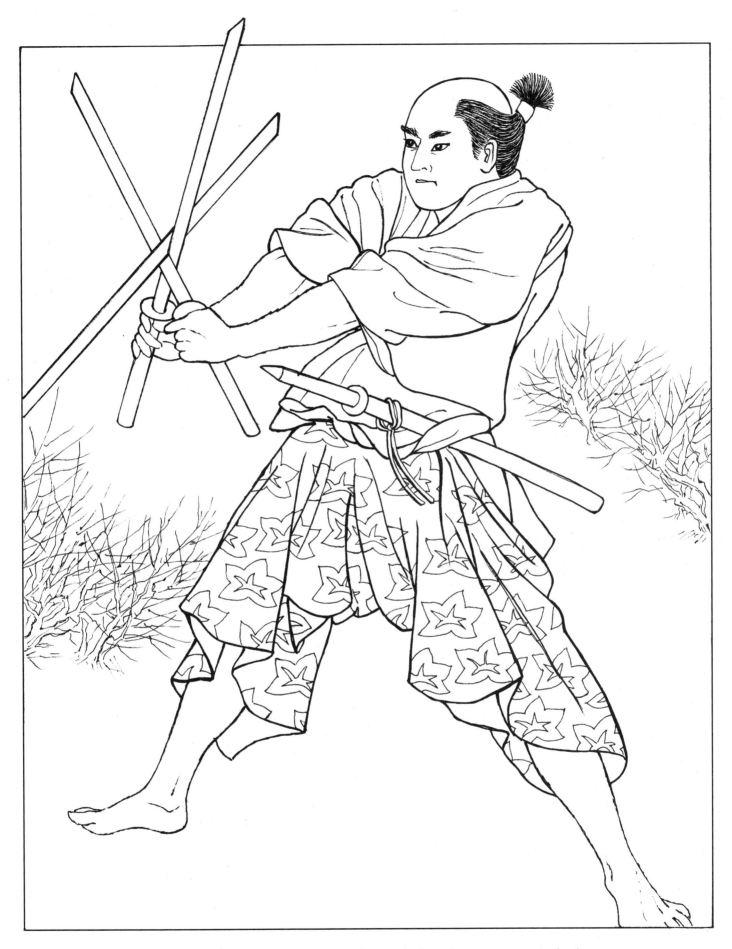

7. This samurai is using wooden swords instead of genuine ones to practice battle techniques with his fellow samurai.

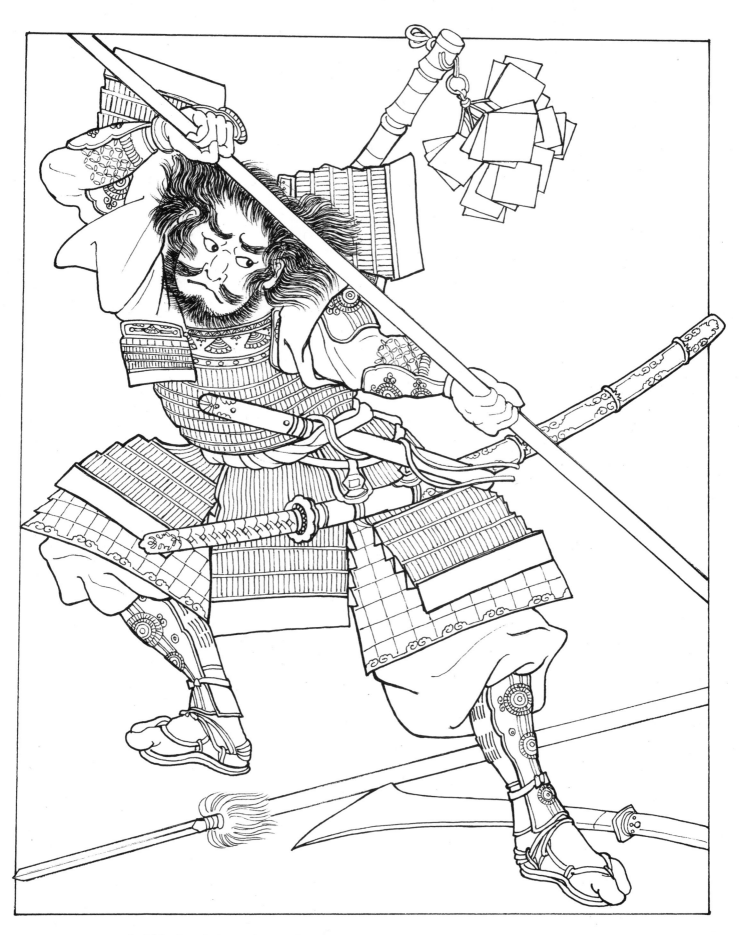

8. This plate depicts Kida Magobee Muneharu in glorious militant form during the period of his service in Hideyoshi's army. The spear on the ground is decorated with plumage that separates the blade and the shaft.

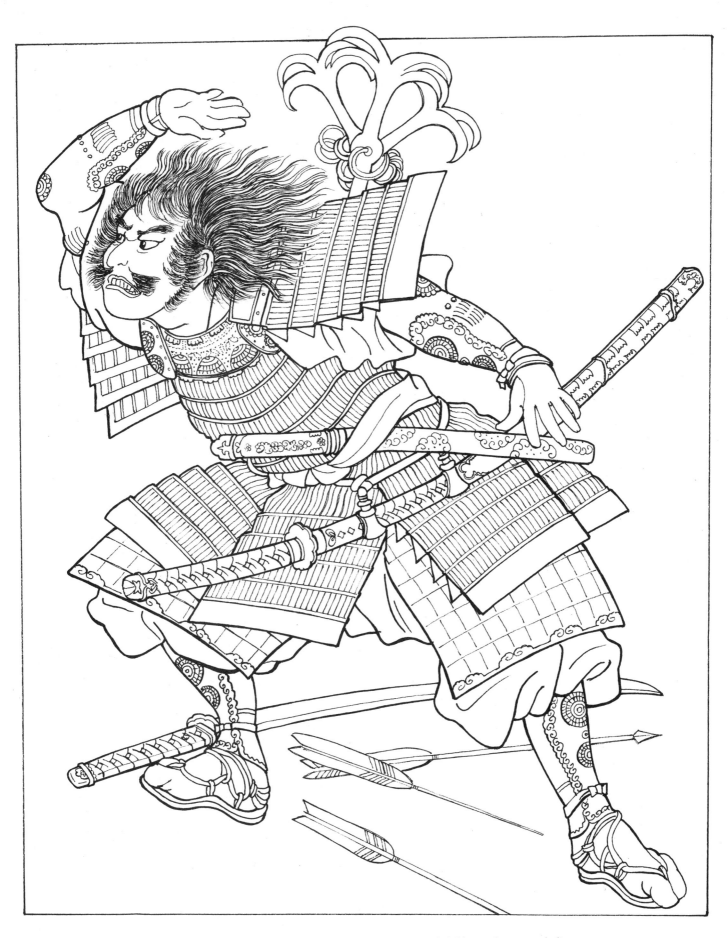

9. Endō Kiemon Naotsugu's weapon, seen above his shoulder, is shaped like adjoined hooks and is known as *kumade* (a bear's clutch). A warrior of great courage, he decided to die bravely in action, and deliberately entered the enemy camp to wage war until he finally succumbed to his fate.

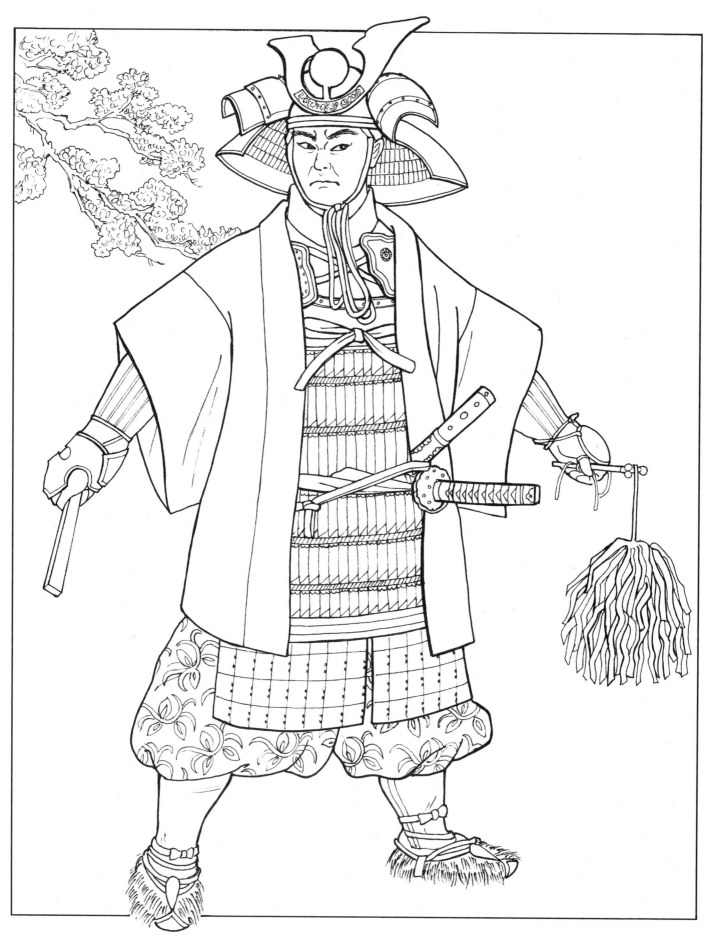

10. This high-ranking commander's baton is used to direct troops in battle. The tassels were made of oiled paper. On his feet he wears *kutsu*, or shoes of bear fur.

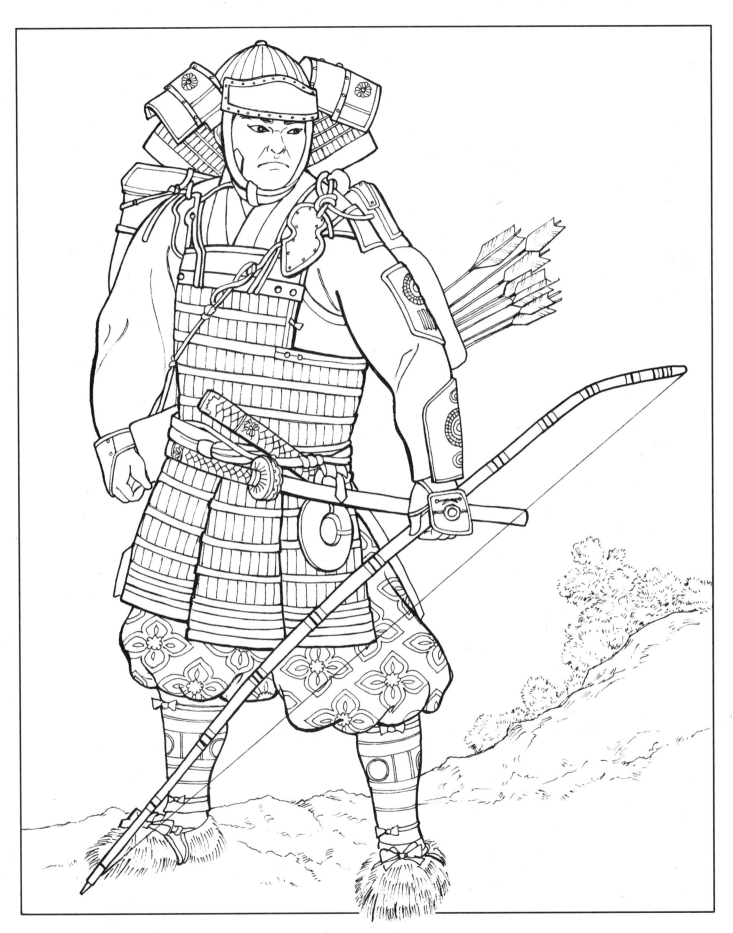

11. Carrying his bow, this warrior wears a helmet with high sides known as *koshozan*. It is made of plates of metal, leather, and silk materials. He also wears shoes of bear fur.

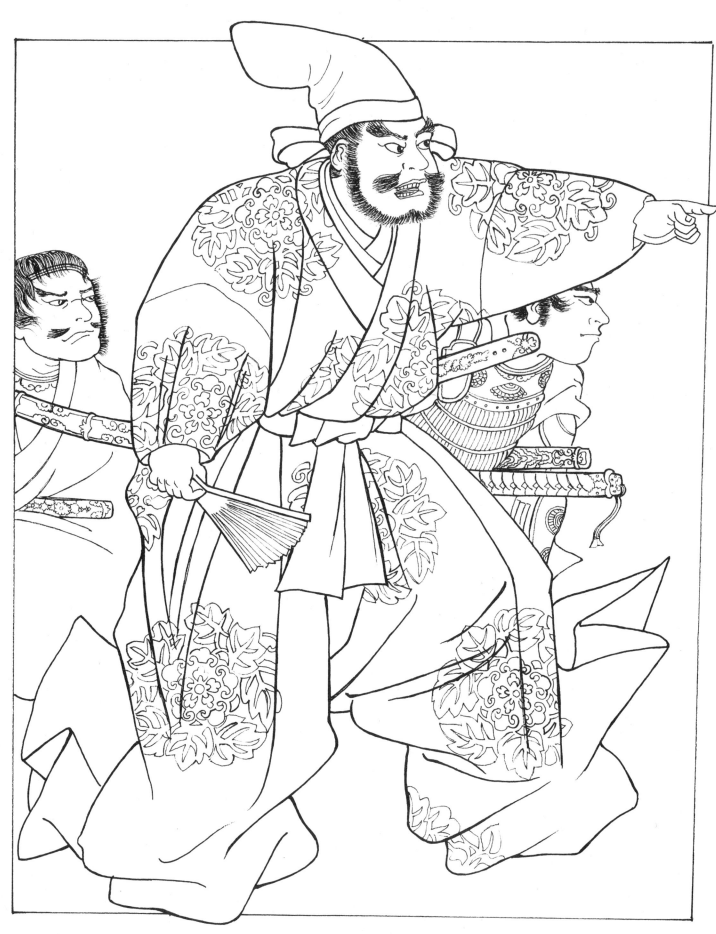

12. This illustration portrays Takigawa Sakon Kazumasu in a long, ceremonial divided skirt (*nagahakama*) and a high hat (*tateeboshi*). In his right hand, he is holding the folding fan of a commander. He is issuing an authoritative command to his vassals, who indisputably carry out his directive.

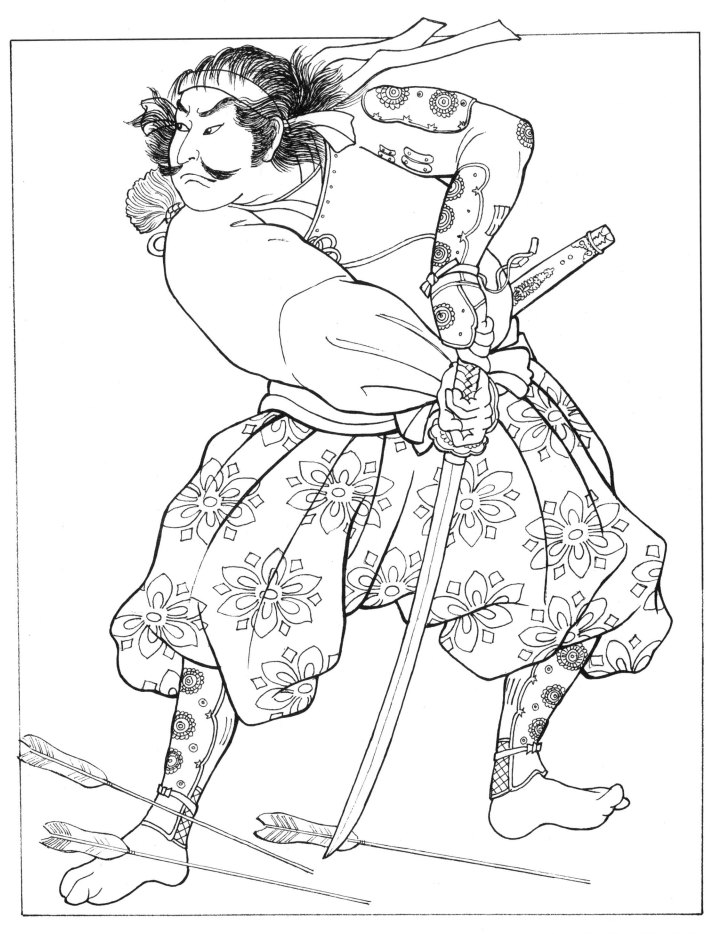

13. Skillfully brandishing his sword, Saitō Uheenotayū Tatsuoki is on the attack, beating down the countless arrows shot at him by his enemies. The warrior's formidable appearance is accentuated by his voluminous robe and divided skirt. His left arm is protected by an armored sleeve, or *kote,* and he wears shin guards.

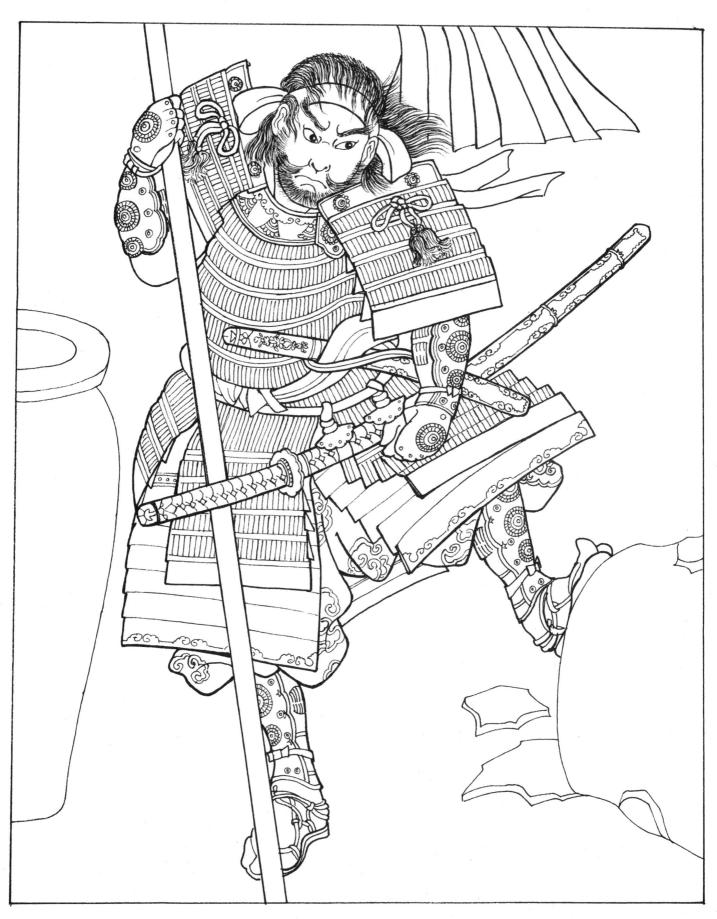

14. In this plate, a very determined Shibata Shurinosuke Katsuie has smashed one of the heavy water jars to leave his troops without water, an act that incited his warriors to fight more ferociously in the defense of Chōkōji Castle.

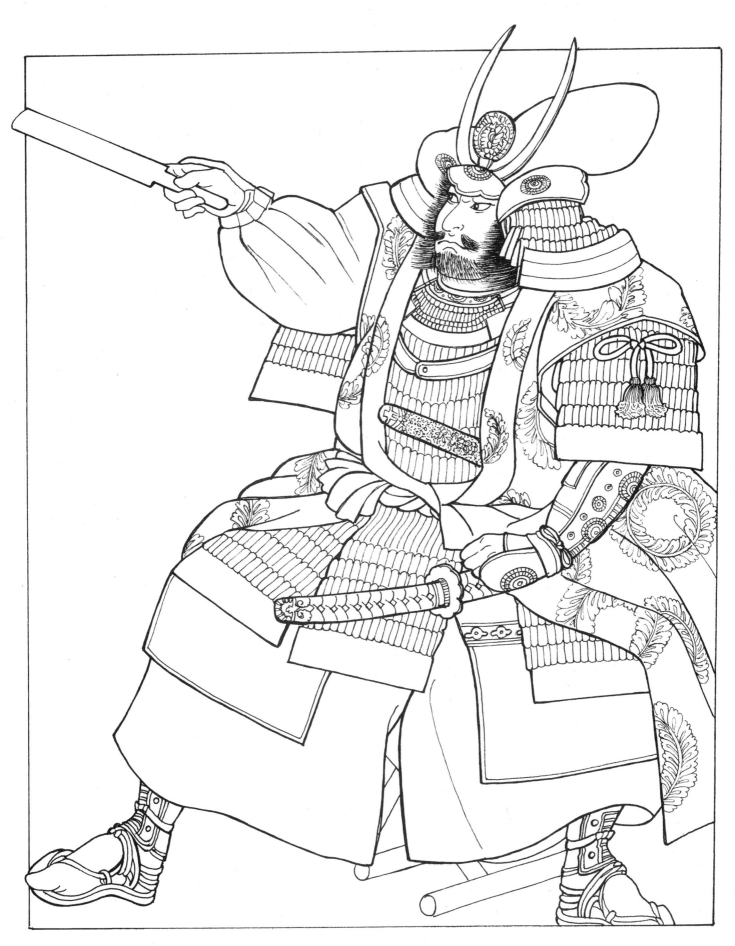

15. Katō Kiyomasa, highly regarded for his valor, is represented during Hideyoshi's first Korean campaign of 1592. At the height of his awe-inspiring glory, Kiyomasa appears here wearing his famous helmet (*eboshi*) and his *haori*, a sleeveless cloak worn over his armor. The cloak is decorated with broad circles, known as a snake-eye pattern.

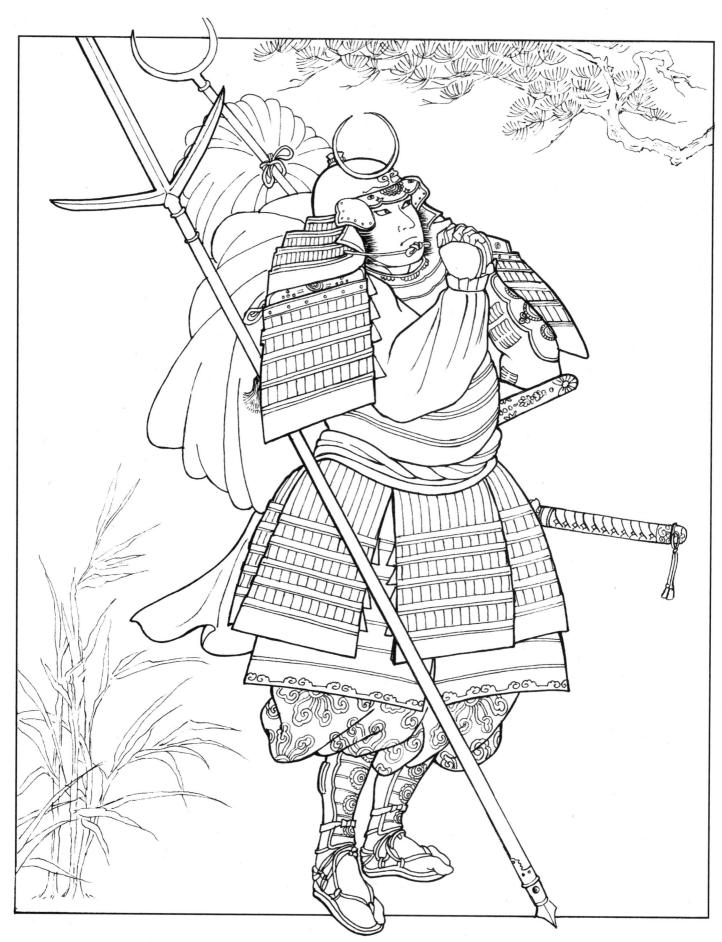

16. Yamanaka Shikanosuke Yukimori, in full military armor, was a firm believer in the three-day moon. His helmet's front plate (*maedate*) bears a decorative horned moon motif, which is also repeated on his individual standard (*sashimono*). He holds a *jūmonji*–type spear with criss-cross blades.

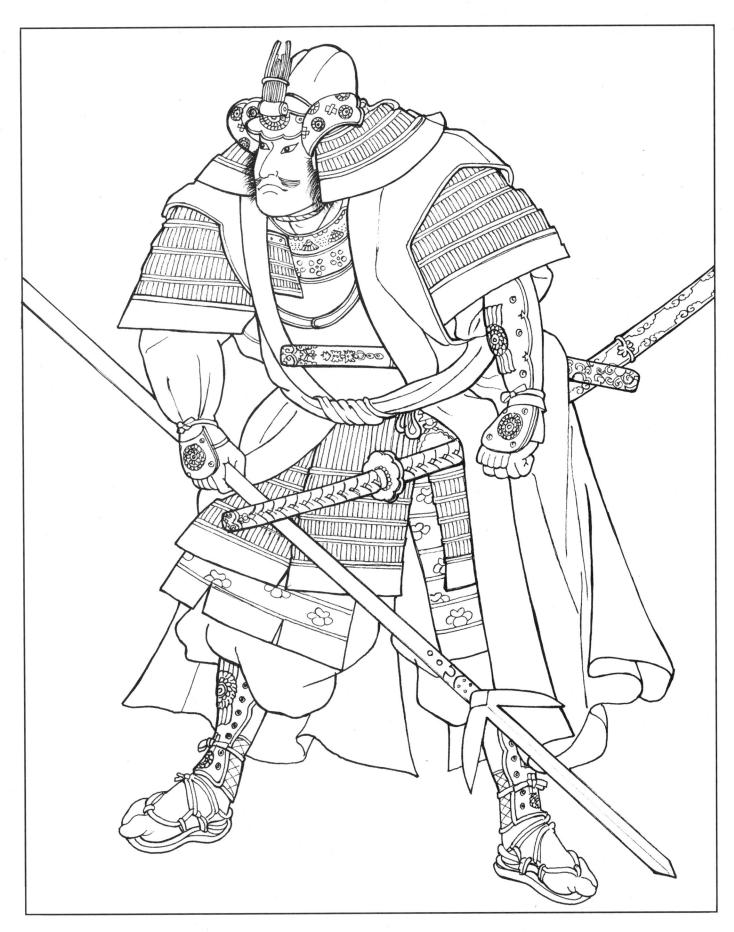

17. A hulking wall of brute strength, Katō Samanosuke Yoshiaki is rendered in full armor, holding his spear in his right hand. More than ready to face his enemy, his unmatched daring made him a force to be reckoned with. He became a commanding general of the Mashiba house, and met his rivals with unflappable bravery.

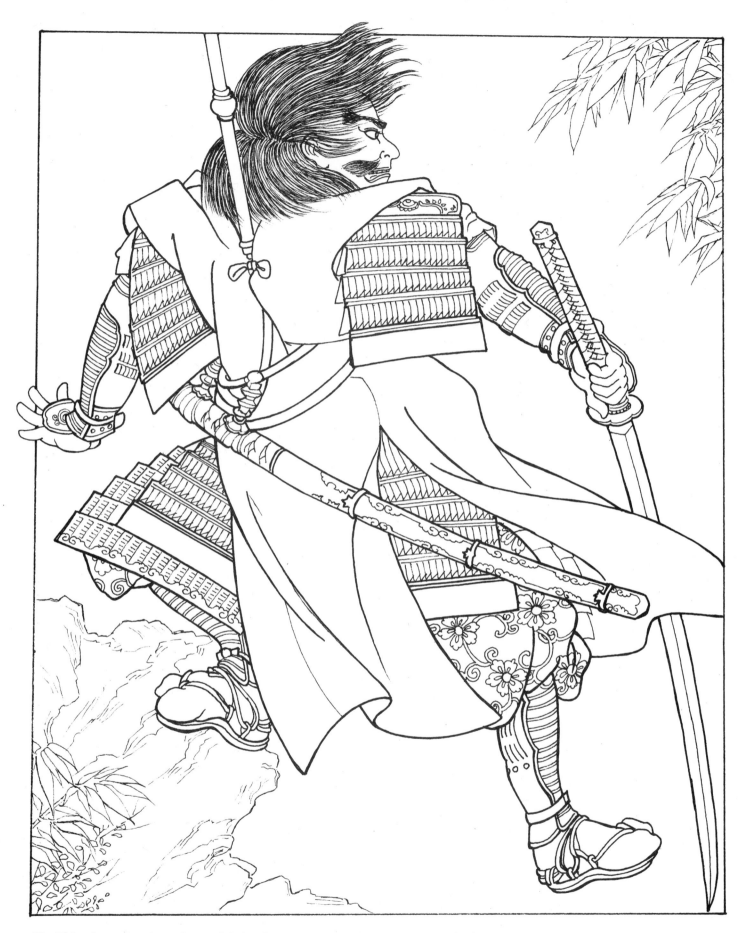

18. This dramatic plate shows Sakai Ukon Masanao just moments before his heroic death. With a ferocious grimace and wildly streaming hair, he is the epitome of warlike spirit. He grips his unsheathed sword tightly in his right hand, while his left is in a militant gesture. He wears a sleeveless cloak (*haori*) over his armor.

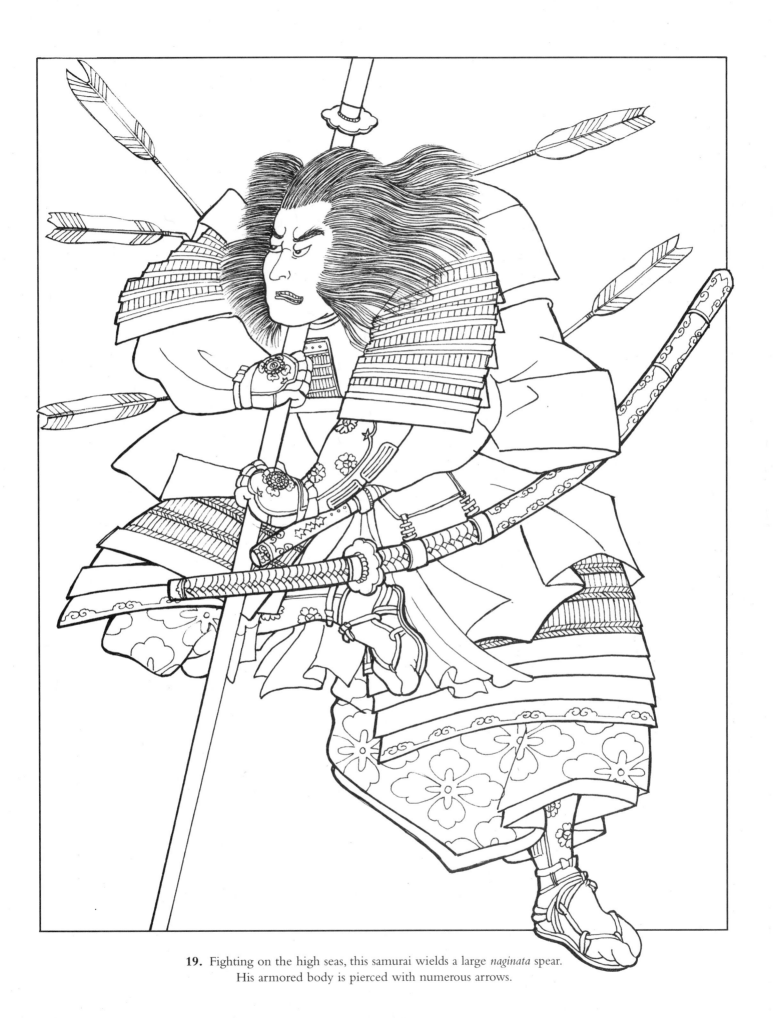

19. Fighting on the high seas, this samurai wields a large *naginata* spear. His armored body is pierced with numerous arrows.

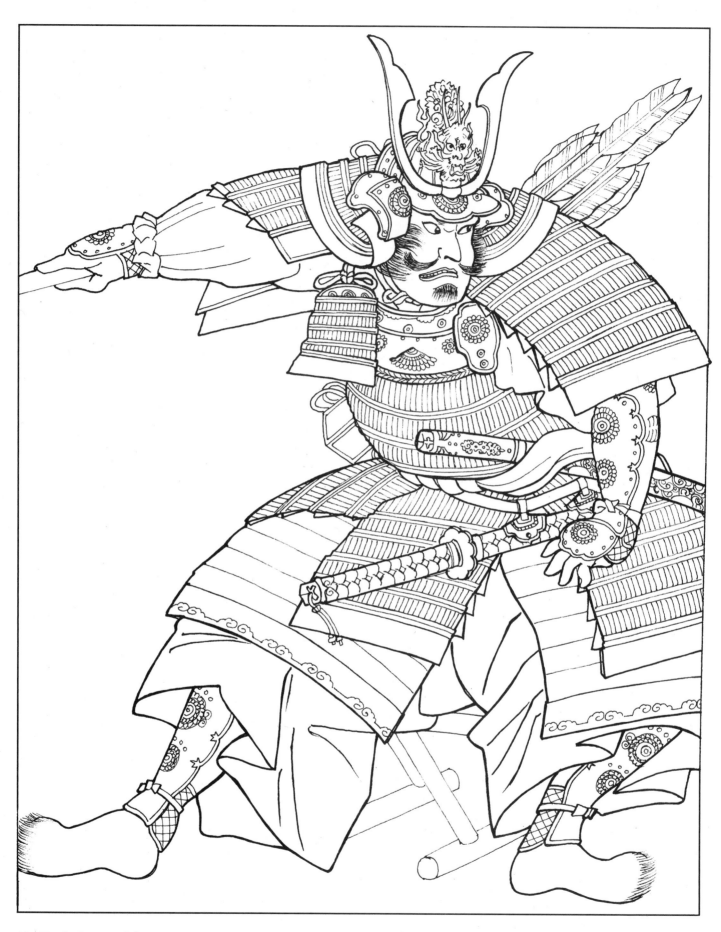

20. Decked out in full armor, Imagawa Yoshimoto is wearing a helmet with protruding horns and fur shoes. He is seated on a stool with a commander's baton fully extended in his right hand. Both his expression and his tense posture indicate his awareness of the danger and risk confronted by his army.

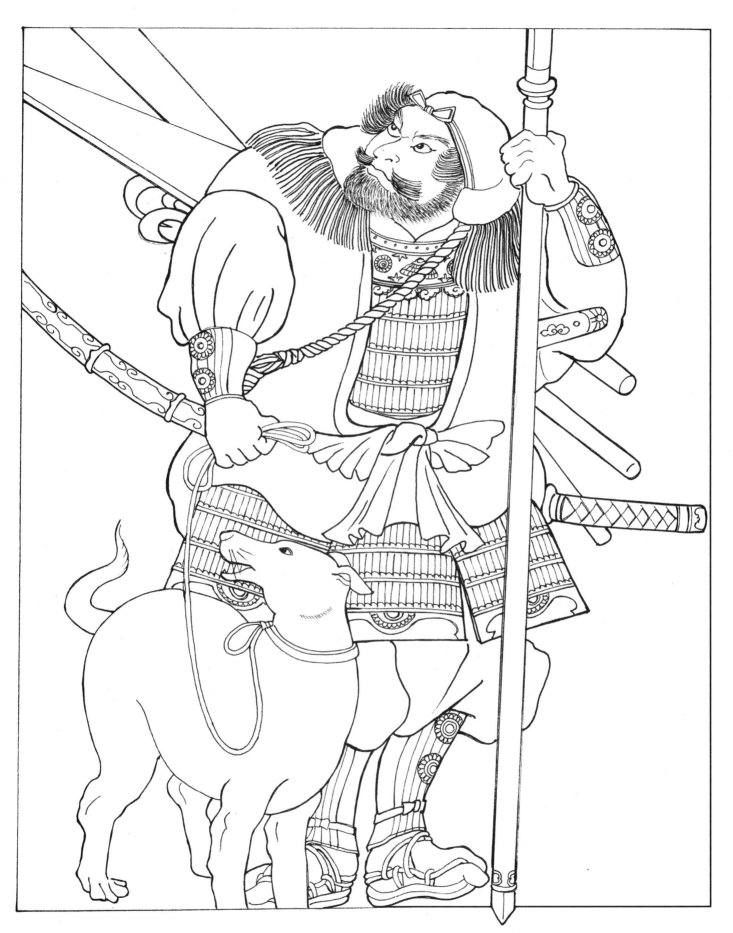

21. Holding a *naginata* spear and carrying additional weapons on his back, this powerful
samurai demonstrates great care for his dog.

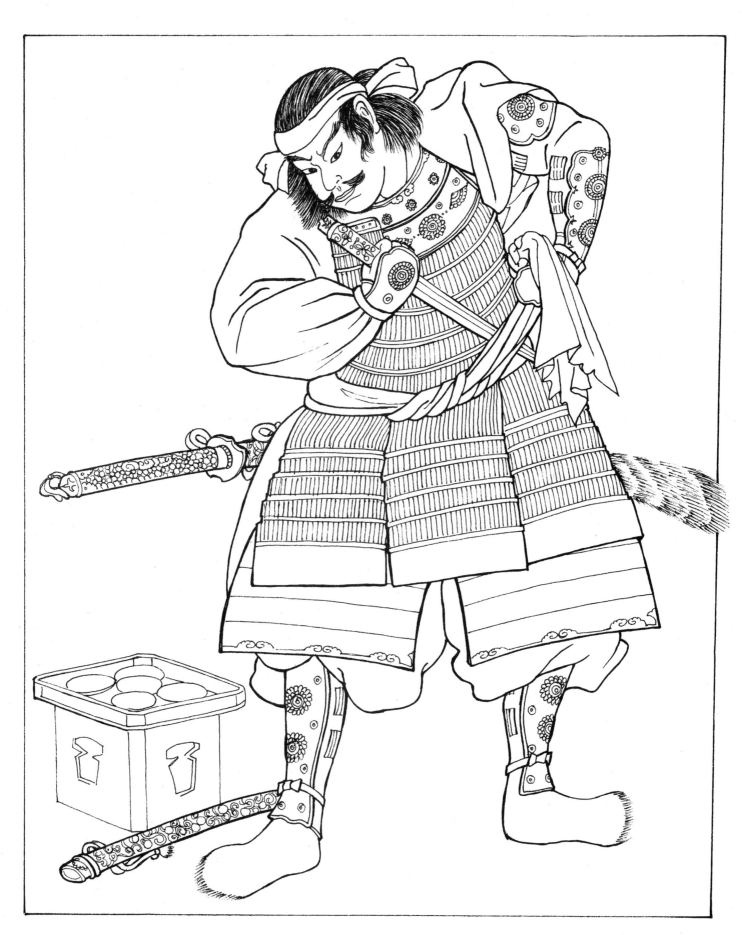

22. After a series of arduous battles, Asakura Saemonnokami Yoshikage set out to retreat to his own province, but his chief vassals betrayed him and he was prohibited from returning. In this drawing, Yoshikage is preparing for his ritual suicide by cutting the cloth of his outer sash. At his feet is a portable table with cups for sake intended for his farewell feast.

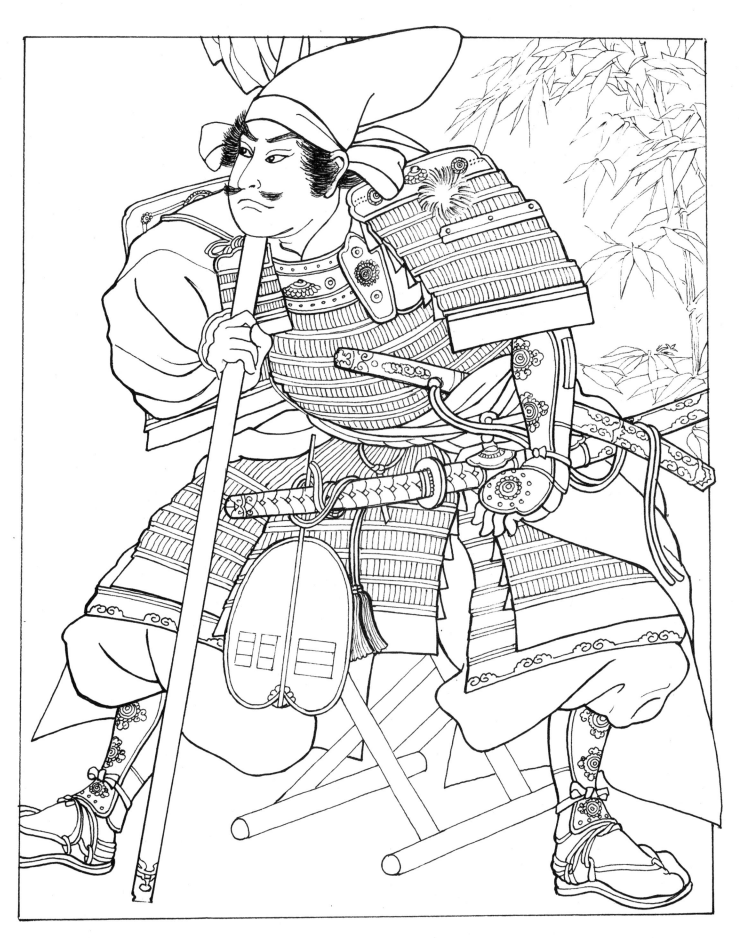

23. During the battle of Anegawa, Isono Tanba-no kami Kazumasa closely watches the action from a campstool. His personal standard or *sashimono* is propped up against his shoulder.

His *gunbai*—the fan of a commander—hangs from the end of his long sword. The fan is decorated with cosmological symbols that represent "earth" and "heaven" from the Chinese classic, *I Ching.*

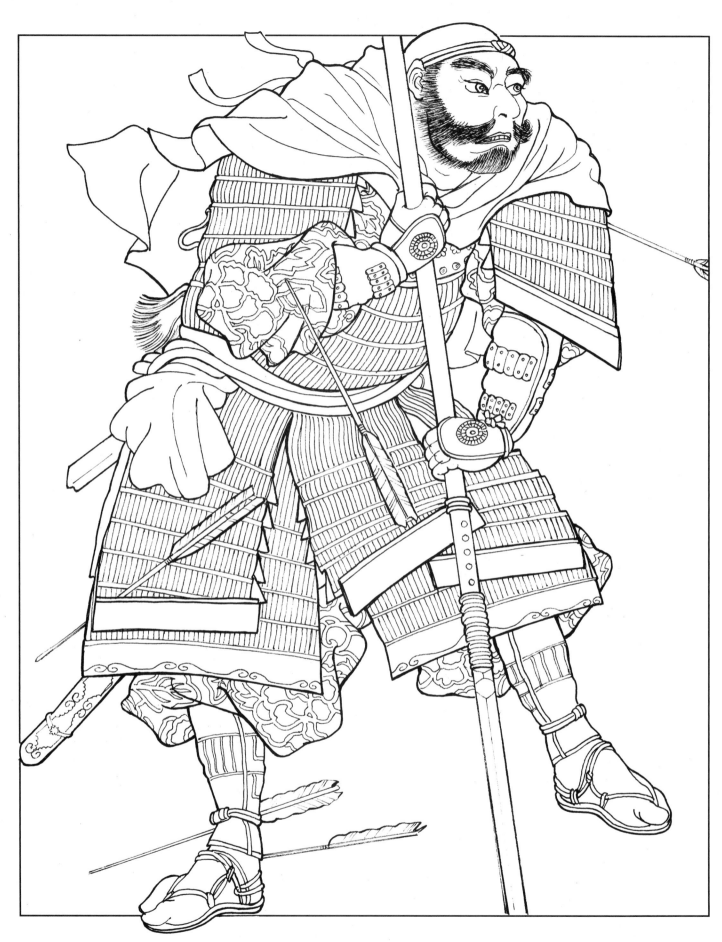

24. This illustration depicts the archetypal romantic image of classic samurai legends. Carrying his *su-yari* spear, the hero is pierced with arrows, but still remains standing strong in spite of his adversity.

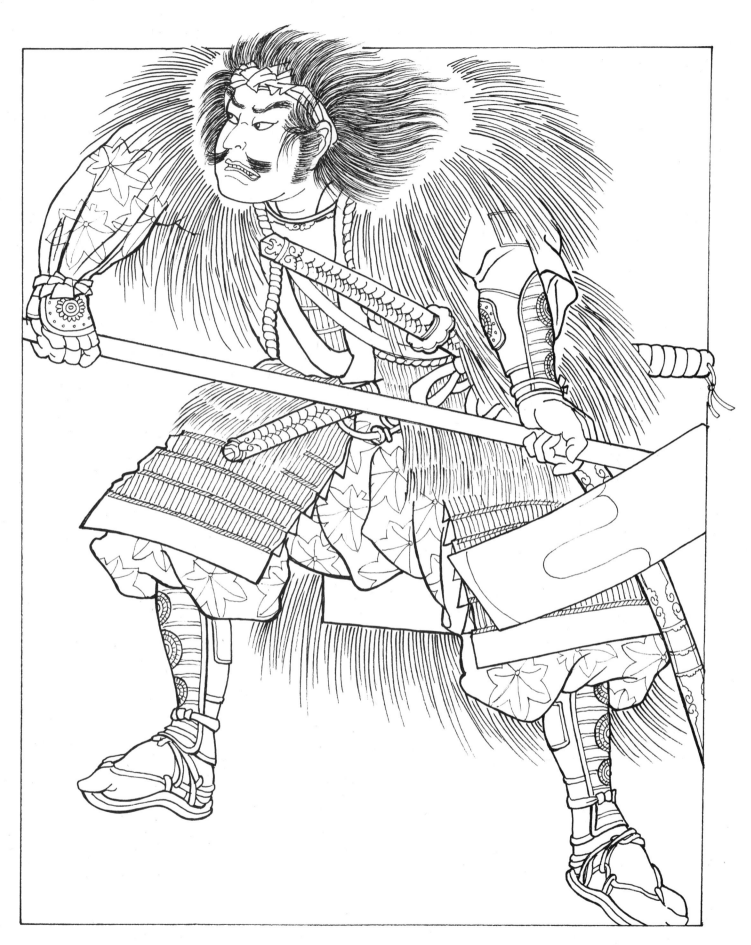

25. A fearsome and intimidating appearance was an essential tool for a samurai warrior. Here, Akashi Gidayū Tadamasu achieves an aggressively threatening look, derived in part from his imposing straw coat. Disguised as a peasant, he also wears a warrior's headband and carries a hoe as one of his weapons.

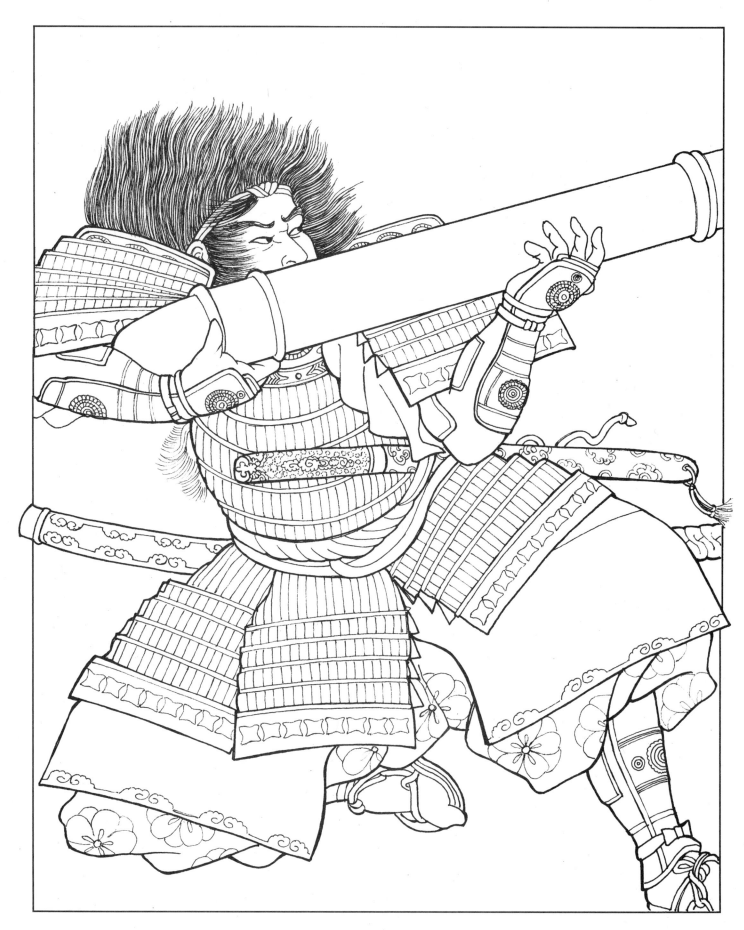

26. Inoue Daikurō Nagayoshi was a brave and robust vassal of the Satō house. This drawing shows him firing a hand cannon, which was most likely made of solid iron and enormously heavy to hold and support during combat. In some of his other exploits, Nagayoshi hurled huge trees and massive stones to press his army's advantage.

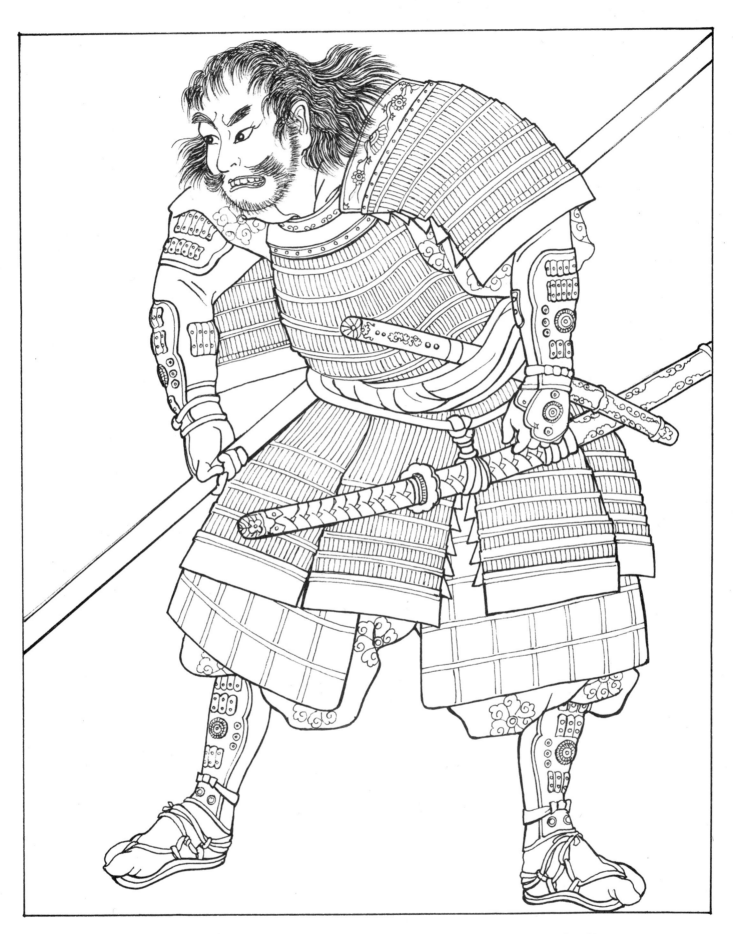

27. A warrior of unparalleled daring, Shiōden Tajima-no-kami Masataka was ordered by his commander to stage an ambush along with more than seventy other warriors. In this plate, the bareheaded warrior is entering the temple to begin his search for Hideyoshi.

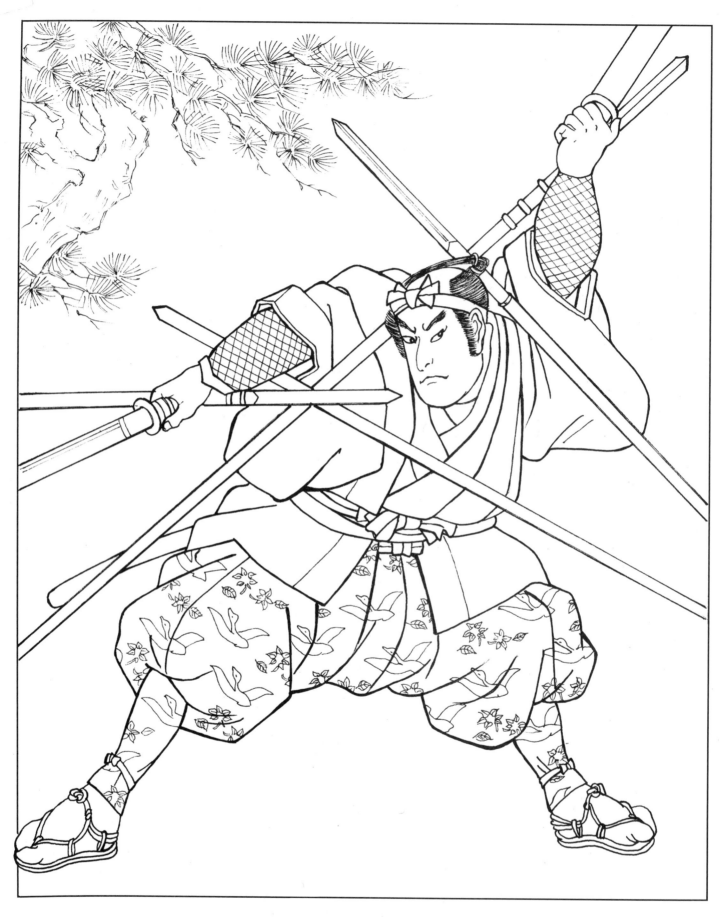

28. Perhaps the best-known samurai of the Tokugawa Period (1603–1868), Miyamoto Musashi was a master in the art of fighting. Displaying outstanding swordsmanship, he became legendary for his superior speed and technique.

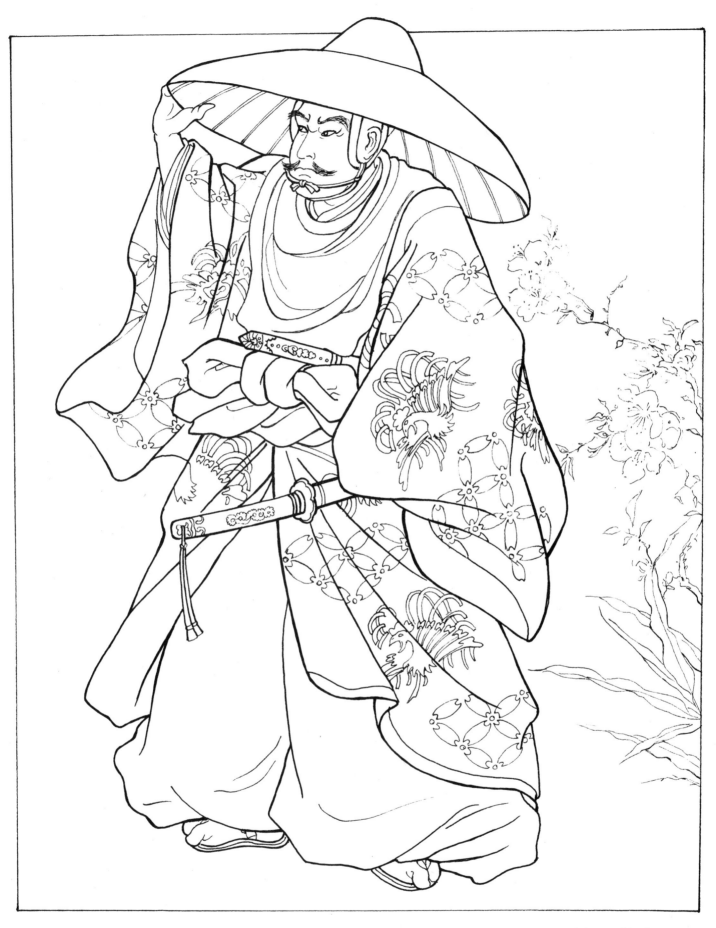

29. In this picture, Saitō Toshimasa nyūdō Dōsan, whose elite stature is evidenced by his richly ornamented cloak, is spying on his future son-in-law after hearing of his eccentricities. His daughter's impending nuptials rely solely on his decision. He slyly holds the brim of his wide hat, prepared to jerk it down to conceal his face to escape detection.

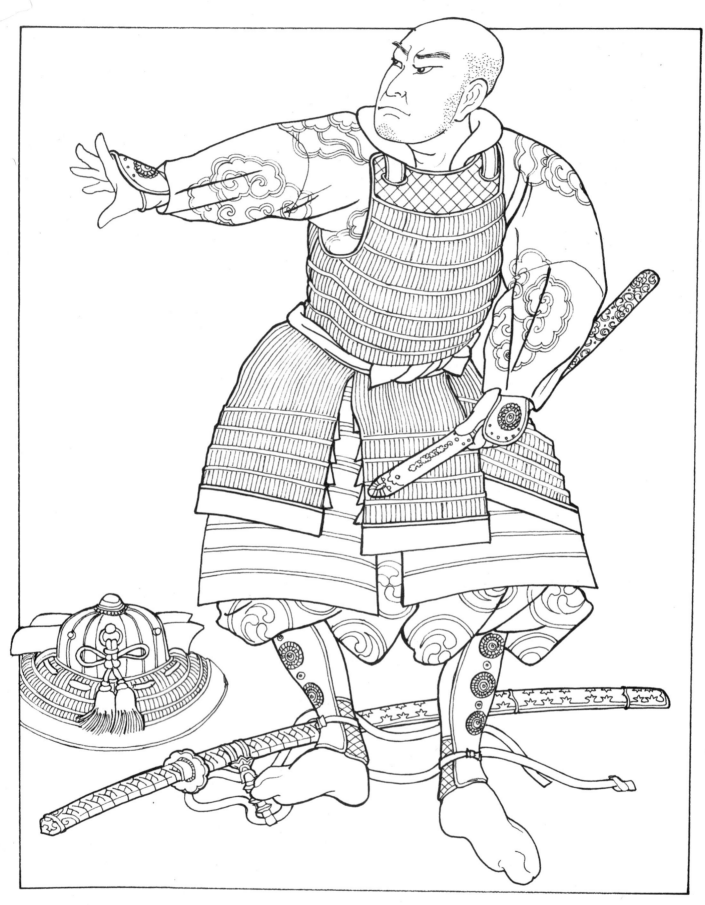

30. As an old and highly skilled vassal of Chibata Tatsuie, Nakamura Bunkasai was bestowed his lord's prized antique vase at the time of his ritual suicide. Bunkasai accepted the honor reverently before he smashed the treasured vase to pieces, an act signifying that he would die together with his lord. This solidarity among warriors was a supreme example of unconditional loyalty and steadfast devotion.